PEEBLES

HISTORY TOUR

ACKNOWLEDGEMENTS

I would like to thank the following people for allowing me to use photographs from their collections: Douglas Whitie, Donald Swanson, Harry Urquart, Deborah Stewartby, Tom and Alison Litster, and Maureen Sansom. I am grateful to Ken Russell for the reproduction of his painting of Biggiesknowe.

First published 2018

Amberley Publishing
The Hill, Stroud,
Gloucestershire, GL5 4EP
www.amberley-books.com

Copyright © Liz Hanson, 2018
Map contains Ordnance Survey data
© Crown copyright and database right
[2018]

The right of Liz Hanson to be
identified as the Author of this work
has been asserted in accordance with
the Copyrights, Designs and Patents
Act 1988.

ISBN 978 1 4456 7811 5 (print)
ISBN 978 1 4456 7812 2 (ebook)

British Library Cataloguing in
Publication Data.
A catalogue record for this book is
available from the British Library.

Origination by Amberley Publishing.
Printed in Great Britain.

INTRODUCTION

'As quiet as the grave ... or Peebles'
Lord Cockburn, *Memorials of His Time* (1820)

The small pastoral community of Peebles merited the above description at the time it was written, having altered little over the preceding six centuries. The settlement in the twelfth century consisted of five streets, the recently built St Andrews Church to the west, the tower and adjoining buildings of Peebles Castle on the elevated peninsular between the Tweed and Peebles Water and clusters of thatched cottages. David I, who frequently visited to hunt in the nearby Ettrick Forest, granted Peebles the status of royal burgh in 1195. A significant discovery of relics in 1261 led Alexander III to order a chapel to be built on the site, attracting pilgrims to Peebles; by 1473 it had developed into a monastery run by Trinitarian friars until the Reformation in 1560. The Cross Kirk was subsequently used as the parish church due to the destruction of St Andrews by the English in 1548. Turbulent times then followed due to incursions by the English across the Borders, bitter feuding between landowners and widespread poverty. A modest defensive wall was even built around part of the burgh in the sixteenth century, a portion of which remains intact.

A few decades after Lord Cockburn's quote, the Industrial Revolution brought rapid changes to the burgh. In the mid-nineteenth century, railway transport from both Edinburgh and Glasgow was brought to Peebles and when the link to Galashiels was completed in 1866, textile manufacturers from the Borders were attracted to establish woollen mills in the town. The new mode of travel also attracted tourists to visit the Tweed Valley, resulting in the creation of new hostelries, the largest of these being Peebles Hydro Hotel, built in 1880. The population increased markedly, necessitating widespread housebuilding on both sides of the river. However, within the next 100 years the transition into a busy little industrial town had reversed, with the mills shut down and railways closed by the end of the 1960s. Despite this, the popularity of Peebles as a commuter location and tourist destination has meant that the community has not only survived but grown to 8,376 residents.

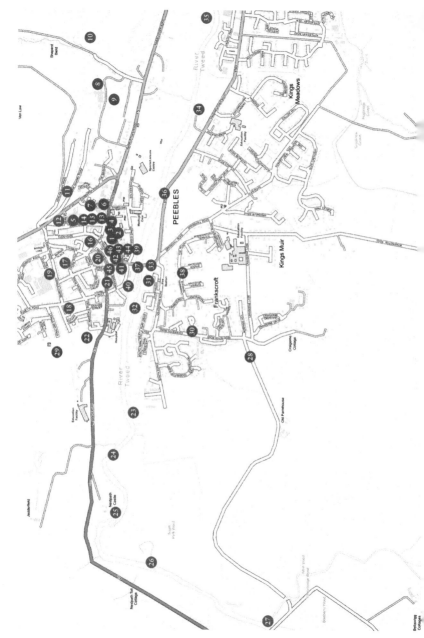

KEY

1. Chambers Institution
2. Quadrangle of Chambers Institution
3. Mungo Park's Surgery
4 and 5. Market Cross
6 and 7. Green Tree Hotel
8. Peebles Hydro Hotel
9. Peebles from Venlaw Quarry
10. Peebles from the East
11. View from Venlaw Hill
12. Peebles East Station
12. Peebles East Station and Signal Box
13 and 14. Northgate
15. Cross Keys Inn, Northgate
16. Tree Bridge
17. Cross Kirk
18. Rosetta Road
19. March Street Mills
20. Biggiesknowe
21. Old Town
22. St Andrews Church
23. Fotheringham Bridge
24. Neidpath Gorge
25. Neidpath Castle
26. Neidpath Viaduct
27. Manor Bridge
28 and 29. Peebles Golf Course
30. Edderston Road
31. Caledonian Station
32. Tweedside Walk
33. Curling Pond
34. Kingsmeadows House
35. Wire Bridge
36. Priorsford Bridge
36. Priorsford Railway Crossing
37. Tweed Bridge
37. Pissoir on Tweed Bridge
38. Peebles from the South
39. Mill Lade
40. Tweedside Mill
41. Peebles Parish Church
42. Bank House
43. Cuddy Bridge
44. Tontine Hotel
45. Veitch Memorial
46. High Street

1. CHAMBERS INSTITUTION

This striking building in the centre of Peebles High Street was originally property of the Cross Kirk, the house on the right being occupied by the dean until it became the seventeenth-century lodging house of the dukes of Queensberry – fragments of this dwelling are still intact. It was purchased in 1857 by Dr William Chambers, local-born publisher and writer, who wished to create a centre of learning 'for purposes of social improvement'. After modernisation and alterations, he presented the library, museum and gallery to the burgh in 1859, roles that are maintained to this day. A plaque on the street façade commemorates the contribution made by Andrew Carnegie in 1911 to extend the library.

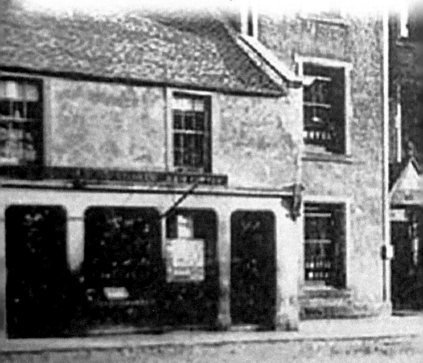

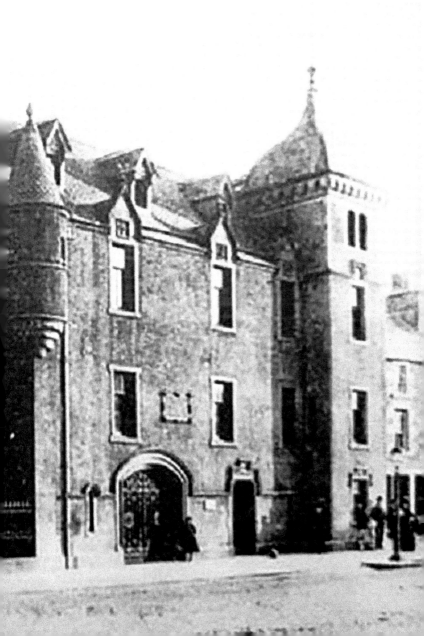

2. QUADRANGLE OF CHAMBERS INSTITUTION

The archway through the Chambers Institution buildings lead into the quiet courtyard of this complex, whose southern side is occupied by the Burgh Hall, also funded by William Chambers. The photograph was taken when the ancient shaft of the market cross was temporarily kept in the quadrangle after restoration, before being reinstated at the junction of Eastgate and Northgate in 1895.

In 1922 the war memorial was installed here. The dome-topped hexagonal enclosure surrounds a Sicilian limestone Celtic cross embellished with colourful mosaic work.

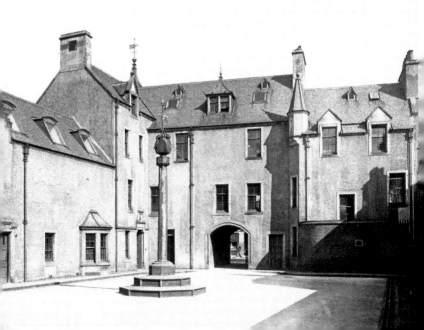

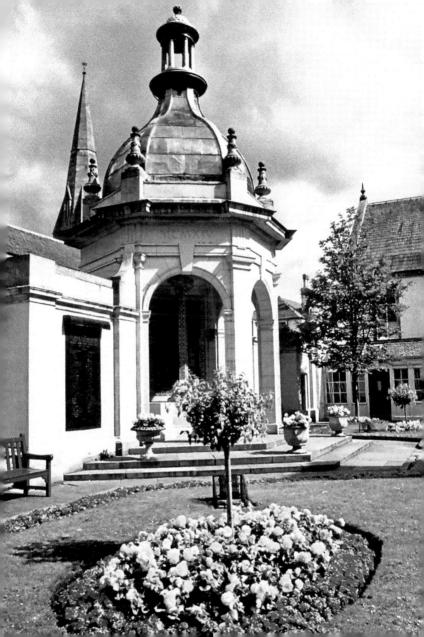

3. MUNGO PARK'S SURGERY

A few yards further up the High Street is the site of the humble premises in which Dr Mungo Park practised as a physician from 1801 to 1804. Prior to this, he had been on a pioneering expedition to the Niger Valley, at a time when little was known about Africa. Despite the difficulties during his African adventure, he found life in Peebles tedious and when invited to go on a second trip to the Niger Valley, he willingly accepted. Unfortunately, it proved fatal – probably by drowning. His residence in Peebles was the house on the corner of Northgate and Bridgegate (marked with a plaque) where he lived with his wife, who was the daughter of a Selkirk doctor, and a Moroccan man brought by Park from London to teach him Arabic.

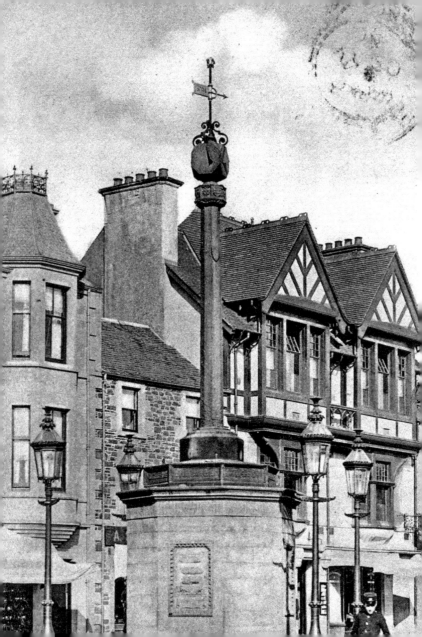

4 AND 5. MARKET CROSS

It is thought that the original market cross was located at the top of Old Town in the fifteenth century but moved to the centre of the road opposite Northgate, where it sat on top of an octagonal platform. By 1807 the weathered shaft became unsafe and the town council decided to replace it, but Sir John Hay of Kingsmeadows House realised the importance of saving this historic artefact and paid for its restoration. The new plinth had four carved stone panels, one of which depicted the three fish of the burgh arms – '*contra nando incrementum*', meaning 'against the stream they multiply'. By 1965 increased road traffic necessitated the cross to be moved a few yards and placed on a lower plinth. The aforementioned panels are displayed in a small garden in Northgate.

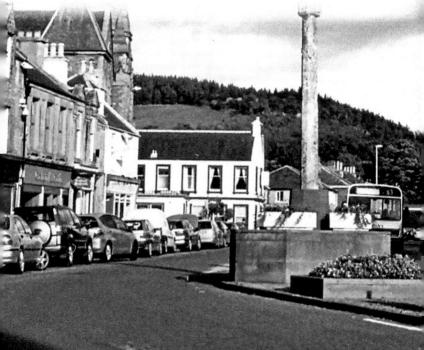

6 AND 7. GREEN TREE HOTEL

This early nineteenth-century inn has been altered and extended several times, and the tree has long since disappeared. It is located at the corner of Venlaw Road, along the line of which ran the town wall, which was built in 1570. A section of the latter can be seen further along this pedestrian route, together with a corner 'blockhouse', or defensive tower. The wall enclosed the area of Peebles on the eastern side of Edderston Water (the so-called New Town), which was more vulnerable to attack than the Old Town to the west. There were four gates, or ports, through the wall: Westgate (leading to Tweed Bridge), Eastgate, Northgate, and Bridgegate.

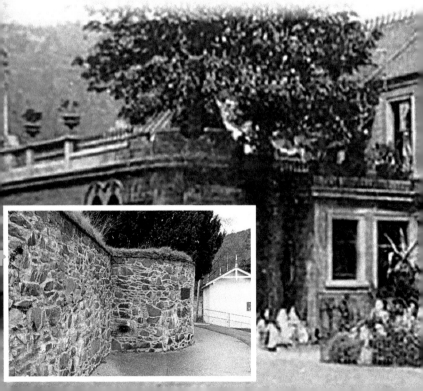

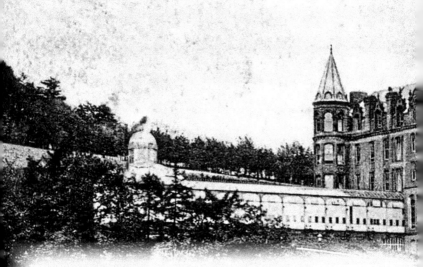

8. PEEBLES HYDRO HOTEL

This £80,000 edifice was built in response to the popularity of Peebles as a tourist destination once it had become easily accessible by rail. The material used was red Dumfriesshire sandstone, and the French Renaissance-style landmark was very aesthetically pleasing. The location – on the south-facing lower slope of Venlaw Hill – afforded splendid panoramas of the surrounding hills. Guests underwent hydrotherapy treatments, which were fashionable at that time, using spring water from Soonhope Burn. Unfortunately, a catastrophic fire burnt it to the ground in 1905, despite the best efforts of the local fire brigade, which at that time were using horse-drawn appliances. The undamaged gates piers and the eastern lodge are still in place.

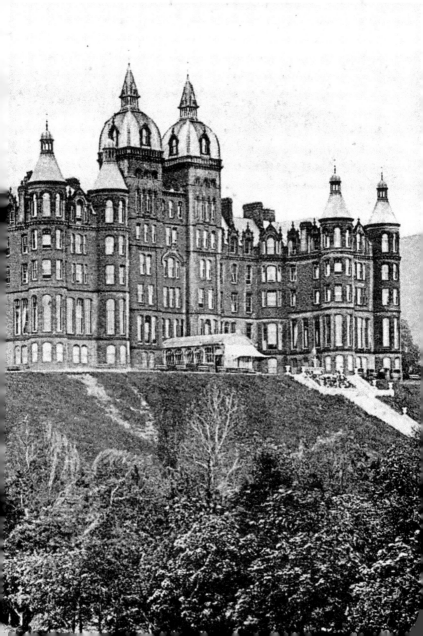

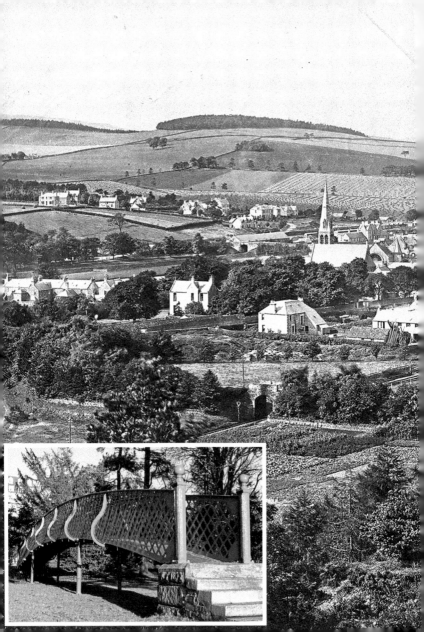

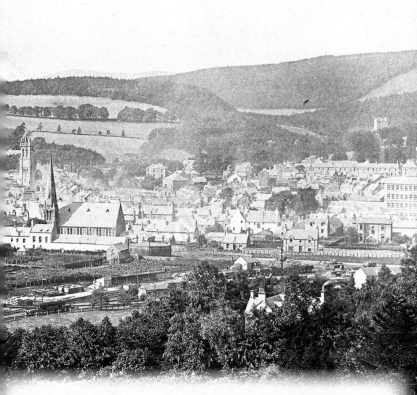

9. PEEBLES FROM VENLAW QUARRY

The quarry on the south side of Venlaw Hill offers a good vista of Peebles. The commercial nurseries are clearly visible in the foreground of this early twentieth-century photograph. Behind these is the railway line from Galashiels, which curves to the right before arriving at Peebles East station. A wrought-iron footbridge (inset) over the railway line was provided for guests of the Hydro Hotel, which was retained even after the line closed and the railway cutting was filled in.

10. PEEBLES FROM THE EAST

After the first Hydro Hotel burnt down in 1905 no time was lost replacing it with a new one, which was completed by 1907. This time the architectural style was Georgian, similar to the Turnberry Hotel in Ayrshire. The beautiful conservatory was replaced in 1970. The hotel was requisitioned during both world wars, as a naval hospital during the First World War and as a general military hospital in 1939. New villas, built around 1910, can be seen lining the Innerleithen Road on the left of the photograph. At the time of writing, further residences – known as Hydro Gardens – are being built.

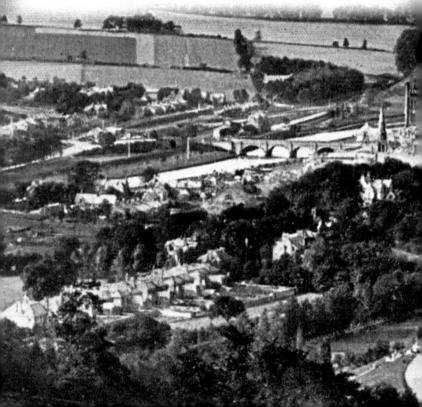

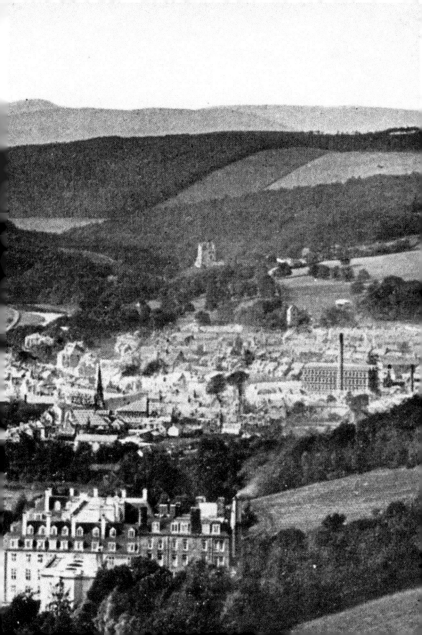

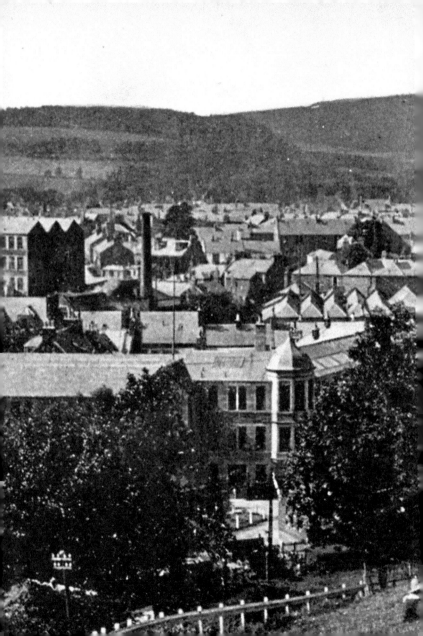

11. VIEW FROM VENLAW HILL

Unlike today, this view is industrial. The large mill on the left was Damdale, which opened in 1869 and was owned by Walter Thorburn & Brothers from 1875. They also owned the large warehouse in the foreground (which was next to Peebles East station), from where they distributed woollen goods around the world. The other mill chimney was at March Street Mills, which was established by D. Ballantyne & Co. in 1885.

12. PEEBLES EAST STATION

The arrival of the first train in Peebles in 1855 was long overdue. By this time the wool and textile businesses throughout the rest of the Borders were flourishing, aided by rail transport links, but Peebles had been bypassed. A group of local entrepreneurs acted to form an independent company, the Peebles Railway, which ran between the town and Eskbank where it joined the Edinburgh–Hawick train on the Waverley route. The North British Railway (NBR) eventually took over the local company in 1876. Peebles East station was renowned for its cleanliness and garden, the terraces of which can be seen on the side of Edinburgh Road.

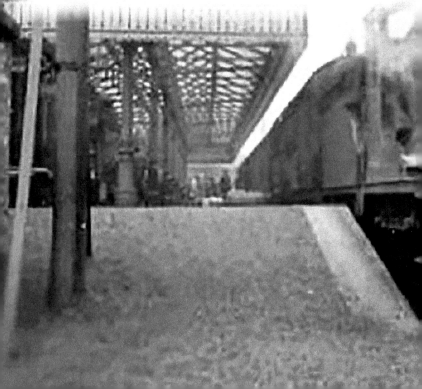

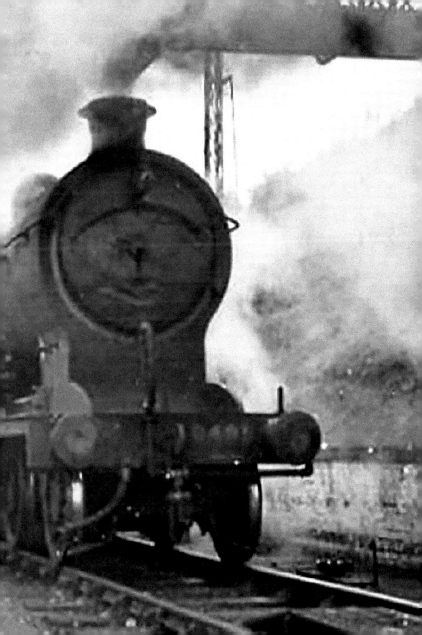

12. PEEBLES EAST STATION AND SIGNAL BOX

The final gap in the railway network was completed in 1866 when the line extended to Galashiels – a branch line to Innerleithen had opened two years earlier. Diesel engines replaced steam in 1958. Road traffic to the north and Edinburgh went up Northgate and crossed a bridge over the railway at the top of March Street, but by the time the NBR line closed in 1962 the narrow thoroughfare was congested and a new road was proposed following the old railway trackbed. A small display of flower beds and an engine plaque denote the site of the station.

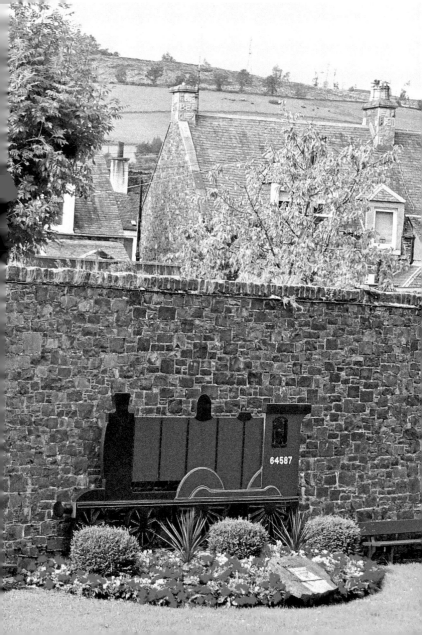

13 AND 14. NORTHGATE

This route out of Peebles has existed since medieval times, and until the eighteenth century led to a track up Venlaw Hill, past the old Smithfield Castle, following the contours of the hills to Leadburn. When the defensive town wall was erected in 1570 entrance to the burgh was through a port in the wall, located at the present-day entrance to Sainsburys. The flat-roofed block beyond this on the right was put up around 1900 and is notable for Arts and Crafts details – particularly No. 46, which has a stained-glass fanlight and large doorplate. Many of the eighteenth-century properties have been demolished or rebuilt but the street remains an interesting mixture of architectural styles.

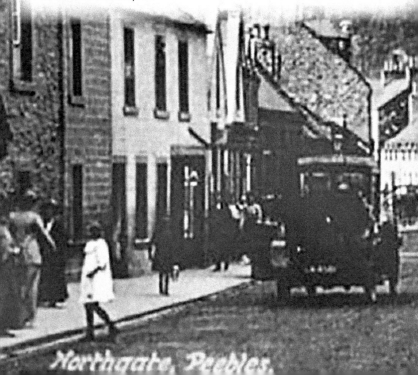

Northgate, Peebles.

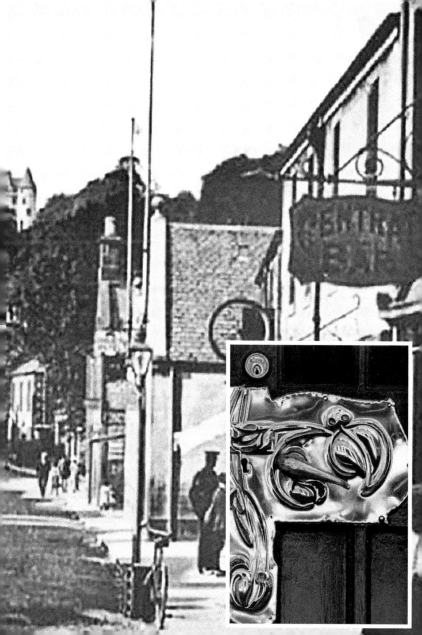

15. CROSS KEYS INN, NORTHGATE

This house dates back to 1693 when landowner Walter Williamson of Cardrona built it to use as his winter town residence. It even boasts a personalised roof: the letters 'WW' can be seen by a keen eye. It was then used as an inn known as The Yett, at which time the cobbled courtyard was walled off from the road. It was run by the Ritchie family, the feisty daughter of whom inspired Walter Scott to create the character of Meg Dods of Ckeikum Inn in his book *St Ronan's Well*. The Cross Keys, as it now called, has recently been taken over by Wetherspoons, who have restored the fabric of the old building.

16. TREE BRIDGE

Records show there has been a crossing over the Eddleston Water at this location (historically called Peebles Water) since at least the mid-1400s. That is hardly surprising as the route through Peebles led from Northgate or Eastgate, down Bridgegate, over the water, turning left along Biggiesknowe and up the Old Town to the west; it was more important than the High Street. Pilgrims visiting the Cross Kirk would also travel this way. In medieval times there was a tollbooth on the east side of this bridge, and before the modern accommodation was built on this site, archaeological excavation work was carried out.

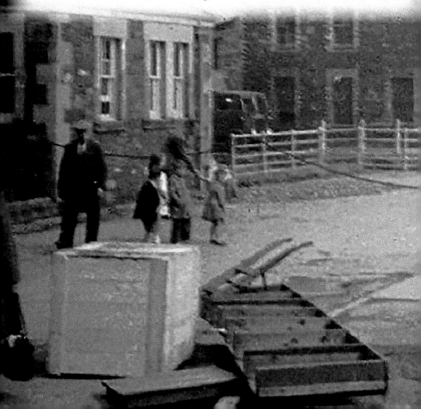

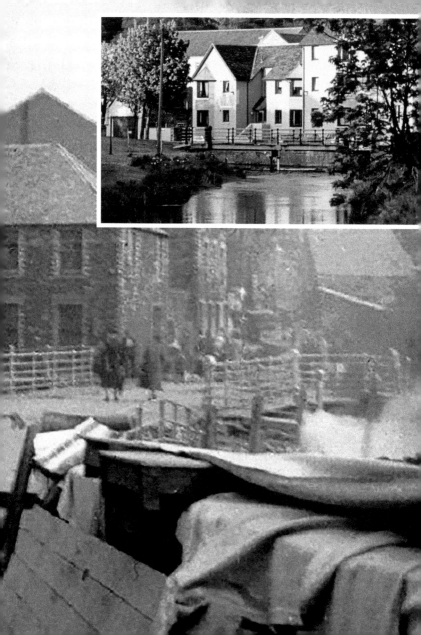

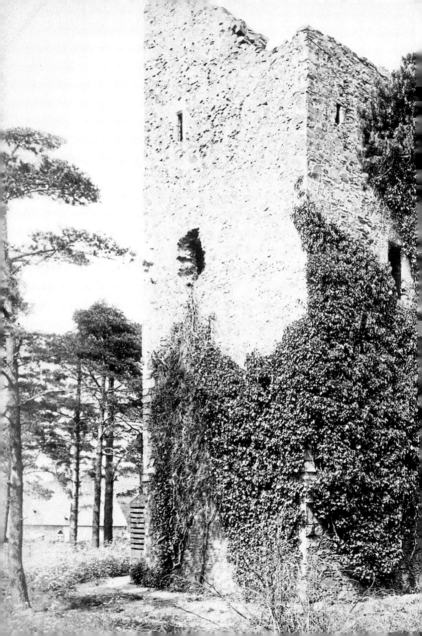

17. CROSS KIRK

This quiet sanctuary near the heart of Peebles owes its existence to Alexander III; when relics, 'a magnificent and venerable cross', human remains and an urn were discovered here in 1261, he ordered a church to be founded on the site. It was ministered by Trinitarian friars and attracted significant numbers of pilgrims. As such by 1474 permission was given to build monastery around the church, which survived until the Reformation in 1560. With the old St Andrews Parish Church in ruins, the Cross Kirk was used instead until a new one was built on Castlehill in 1784. It is now in the care of Environment Scotland.

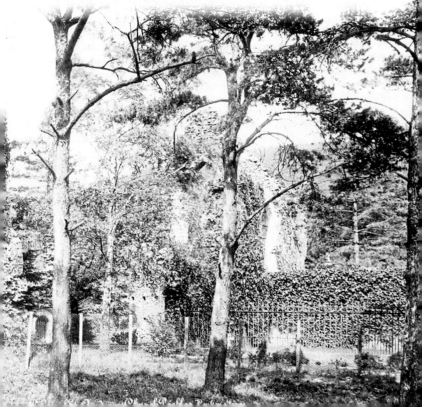

18. ROSETTA ROAD

The fast growth of Peebles' population in the second half of the nineteenth century necessitated expansion of housing stock, which had been virtually static for centuries. Ludgate (now Young Street) was a short road on the right at the top of Old Town, lined with a few thatched cottages. This began to be extended northwards in the late 1880s. Many of the houses bear a date and a walk along Rosetta Road illustrates the rate of development, together with changes in architectural design. Rosetta House (at the far end) was built in 1807 for Thomas Young, a military surgeon who had returned to Peebles from the Battle of Alexandria. A facsimile the Rosetta Stone is displayed in the hallway.

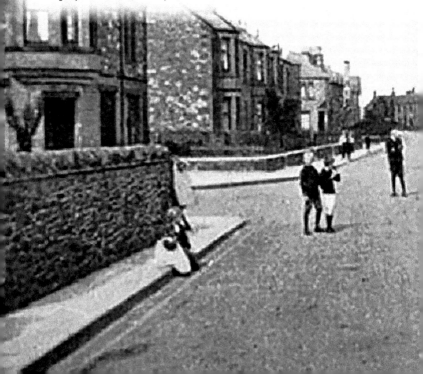

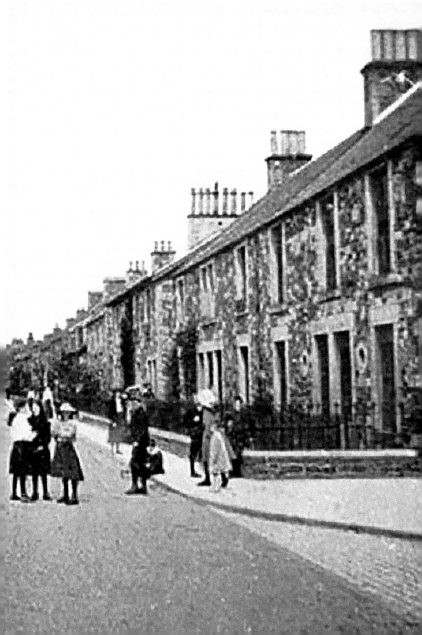

19. MARCH STREET MILLS

The closure of this textile factory in 2015 marked the end of the era of woollen manufacturing in Peebles, an industry that had been the catalyst for transformation of the sleepy, rural burgh to a thriving, prosperous town in the second half of the nineteenth century. March Street Mills was established in 1884 by D. Ballantyne & Co., the family having been involved in Borders textiles for nearly 200 years. Situated close to the station, railway sidings within the mill enclosure linked up to the main line. The landmark mill chimney, the last in Peebles, was demolished in 1980 but no decision has yet been made about the future of the site.

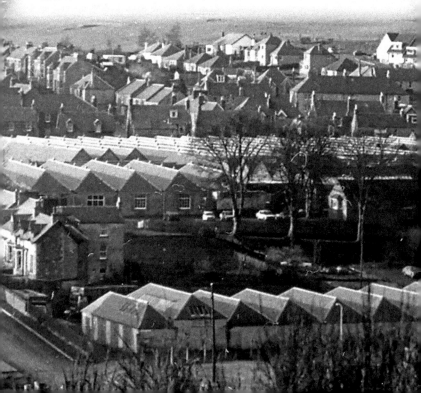

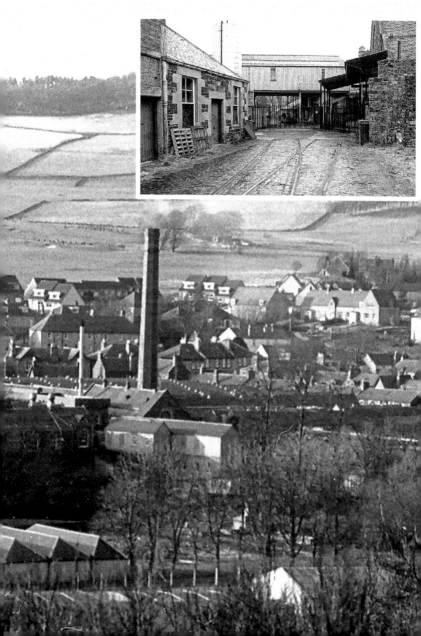

20. BIGGIESKNOWE

This narrow characterful street was part of the main route through Peebles until a new bridge was built across the Cuddy in 1857. It was the centre of the eighteenth-century handloom weavers, one of whom was Glaswegian cotton weaver William Chambers (d. 1799), who set up a successful manufactory in Old Town and built a house for his son James in Biggiesknowe. He, unlike his father, was not a good businessman and went bankrupt but his two sons, William and Robert, driven by a thirst for knowledge, strove to overcome the hardship of their lives in Edinburgh and became renowned in the publishing realm. W. & R. Chambers left a legacy through their journals, dictionary and encyclopaedia. There is a plaque marking the house in which they grew up.

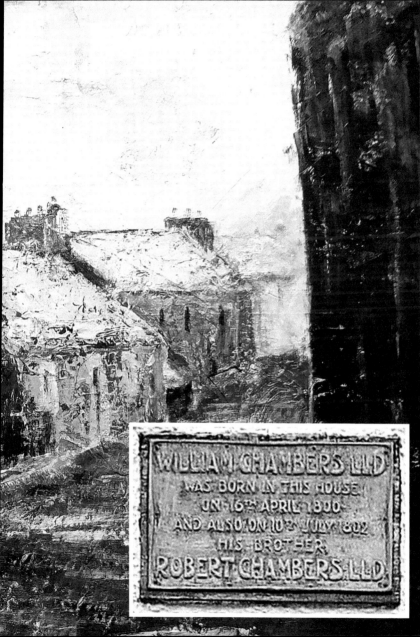

WILLIAM CHAMBERS LLD
WAS BORN IN THIS HOUSE
ON 16TH APRIL 1800
AND ALSO ON 10TH JULY 1802
HIS BROTHER
ROBERT CHAMBERS LLD

21. OLD TOWN

The short, steep road uphill to the west of Peebles is known as Old Town and has been used for centuries to reach the old St Andrews Parish Church, Neidpath Castle, Clydesdale and beyond. At the foot on the left, Bridge House was built in 1878 for the Peeblesshire Co-operative Society, while on the opposite corner was the United Presbyterian Church of St Andrew, which was built in 1847 and demolished in the late 1970s when a sheltered-housing complex was built on the site. At the top, on the corner of Young Street, is the house called Lindores from which Dr Clement Gunn practised medicine for fifty years.

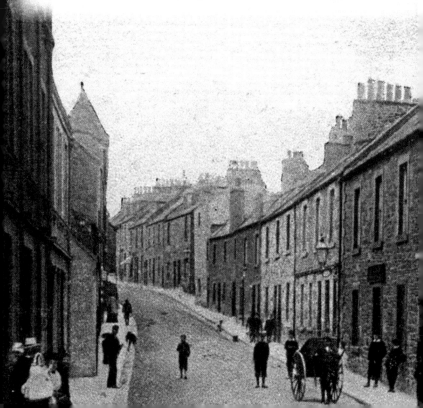

22. ST ANDREWS CHURCH

Dedicated in 1195 by Jocelin, Bishop of Glasgow, but thought to have existed earlier that century, these medieval remains are the oldest in Peebles. The church had eleven altars but the only original stonework remaining is part of the north wall – now covered by ivy. The English burnt the church in 1548, rendering it unusable, and the congregation moved to Cross Kirk for worship. Tradition suggests that the ruins were used as stables for Cromwell's horses when he besieged Neidpath Castle, but this is not in written records. William Chambers paid for the tower to be restored in 1883, although the original had a flat roof rather than the craw-stepped one of today. The entrance door is where the archway led into the tower. There are some notable gravestones in the churchyard, particularly the table tombs of Thomas Hope (1704) and the Tweedie family (1708).

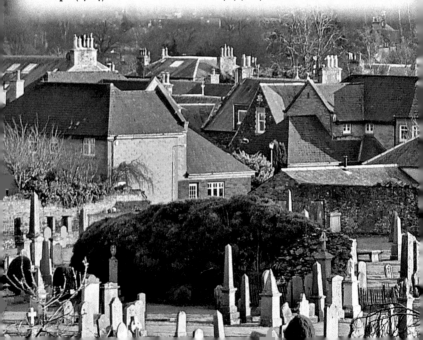

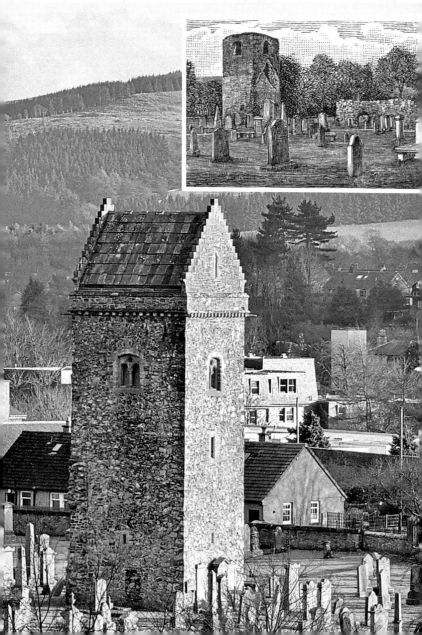

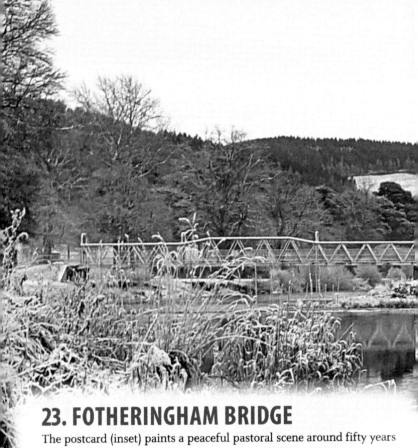

23. FOTHERINGHAM BRIDGE

The postcard (inset) paints a peaceful pastoral scene around fifty years prior to the river being bridged in 1953. The idea of a bridge, however, was not new: between the world wars Glasgow University Training Corps, while attending a training camp in Hay Lodge Park, erected a temporary river bridge as an exercise, which proved popular with locals. Native Peeblean John Fotheringham emigrated to South Africa, where his family started a successful bakery business (he was also mayor of Johannesburg in 1937–38), but wanted to give something back to his home town and so paid for Fotheringham Bridge to be built.

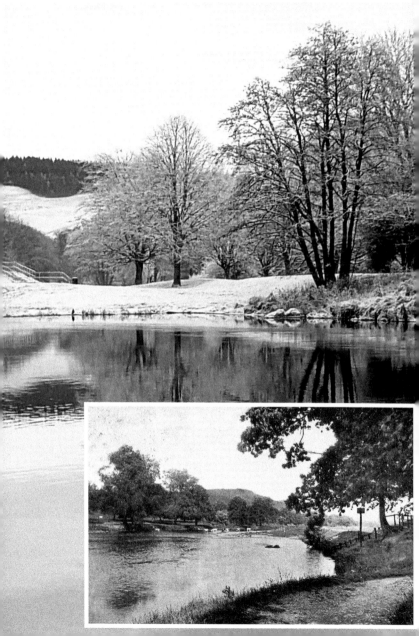

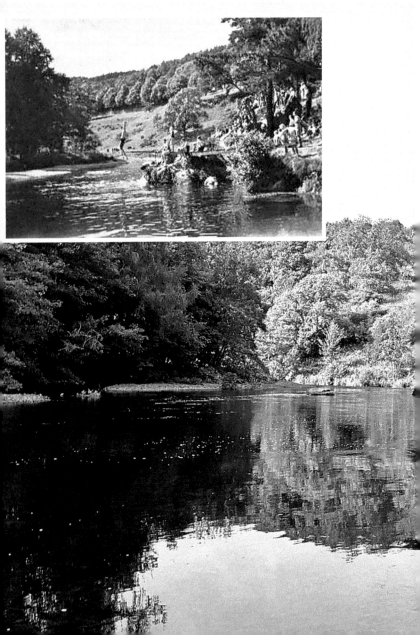

24. NEIDPATH GORGE

From the wide stream of the River Tweed below Neidpath Castle, the water is suddenly channelled into the fast-flowing rocky gorge before levelling out at the entrance to Hay Lodge Park. The deep pool below the last outcrop was a popular location for Peebles swimmers, who were able to dive off a metal diving board known as the Dookits. Once the indoor swimming pool at the Gytes was opened in 1919 (funded by Sir Henry Ballantyne), only the keen types continued to use it. By the 1950s the structure had been removed.

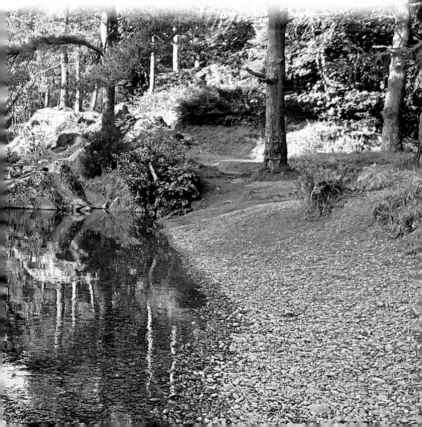

25. NEIDPATH CASTLE

The elevated position overlooking the Tweed Valley to the west of Peebles was a natural defensive place to build a castle. It is thought that a small peel tower was erected here around 1190 by the then landowners Frasers of Oliver Castle, but in the fourteenth century an L-plan three-storey tower house was built for Sir William Hay, whose grandson married into the Gifford family and hence inherited Yester Castle, which became their main residence. Neidpath Castle was still used to entertain visiting royalty including Mary Queen of Scots and later her son James IV. Oliver Cromwell's troops attacked and damaged the oldest part of the castle in 1650, after which it was remodelled by the 2nd Earl of Tweeddale, who also planted the driveway with yew trees. By 1795 it was falling into disrepair, having been neglected by its owner – 'Old Q', 4th Lord Queensberry (who had also shamefully vandalised the ornamental trees in the grounds) – and has not been inhabited since.

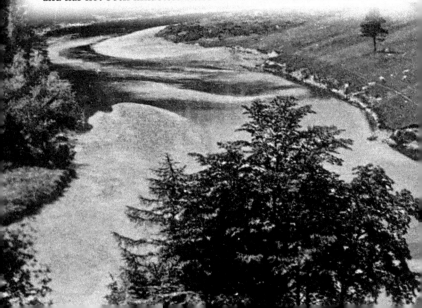

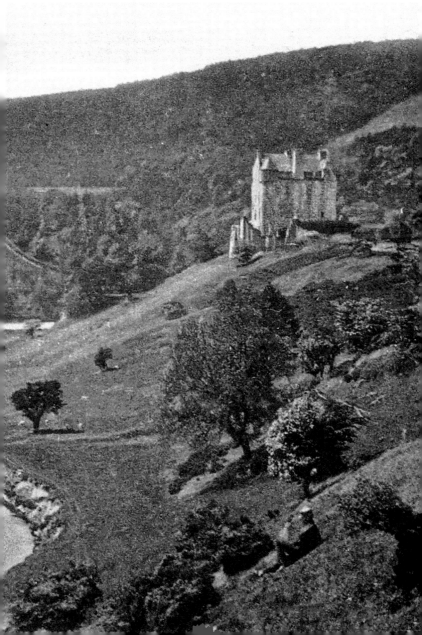

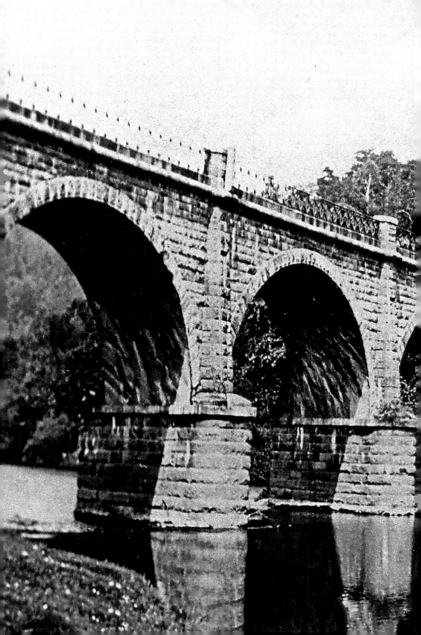

26. NEIDPATH VIADUCT

Following the success of the Peebles–Edinburgh railway, a rival company, Caledonian Railway, set its sights on opening a route from the west. They took over the Symington, Biggar & Broughton Railway and were granted permission in 1861 to extend this line to Peebles. A further three years passed before the line opened, due mainly to the challenges of Neidpath Gorge; the narrowness and steepness were problematic for construction but also the landowner objected to the potential noise and disruption. Therefore, both a viaduct and a tunnel needed to be built, both of which required time and expertise. This remarkable skew bridge proved a difficult task for engineers, designers and stonemasons but is now Grade A listed.

27. MANOR BRIDGE

The old single-arch bridge replaced a ford in 1702 and was paid for using the stipend of the then vacant charge at Manor Kirk. For the last decade it has only been used by cyclists, horses and pedestrians due to its condition. The newer one of 1883 over the Tweed, situated just upstream from a ford, was funded by local benefactor David Kidd, who lived in Manor Valley. He was a successful industrialist who ran a large stationery business and was the proprietor of Inveresk Paper Mills.

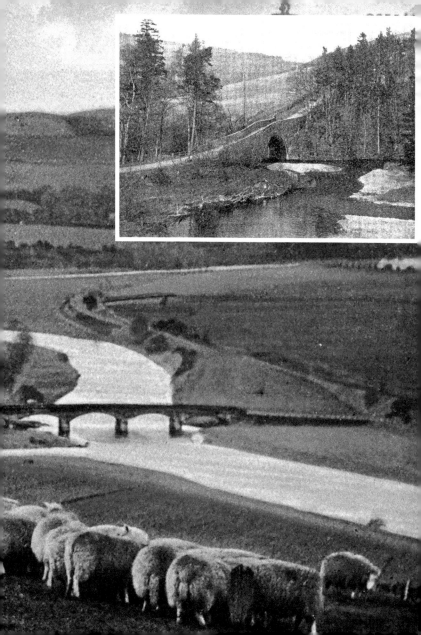

28 AND 29. PEEBLES GOLF COURSE

The first nine-hole golf course was laid out in 1892 on Edderston Farm land at Morning Hill, with a small pavilion serving as the clubhouse. It soon became apparent from its popularity that a full eighteen-hole course and facilities for the large membership was required. In 1918 the town council purchased ground from Wemyss and March estates at Kirklands and Jedderfield for this purpose. The larger clubhouse built at that time was rebuilt in 1998, then extended again in 2017.

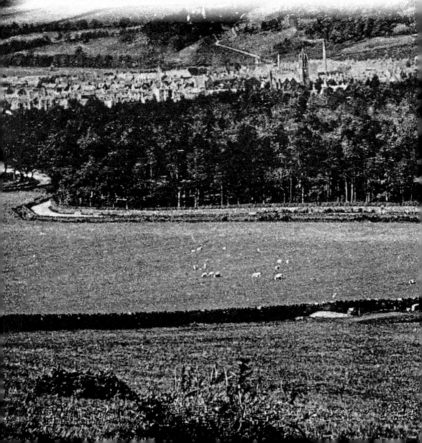

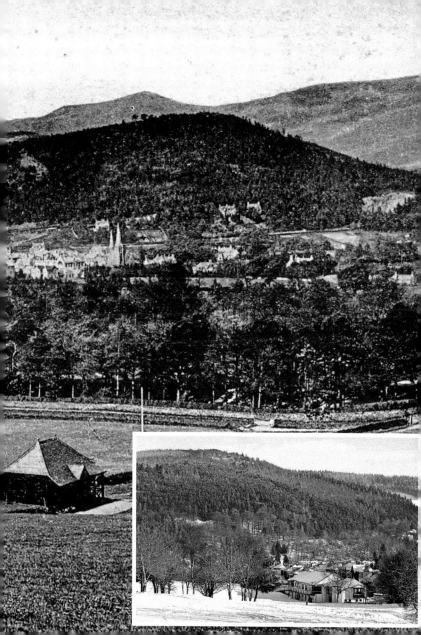

30. EDDERSTON ROAD

At the time of the photograph on the previous page, there was no housing on this road; however, due to the arrival of two railways, three mills and burgeoning tourism, the population increased sharply – from 2,045 in 1861 to 5,266 in 1901 – creating an acute shortage of living accommodation. The south side of the river had some substantial Victorian villas such as Springwood House, Craigerne House and Kingswood House but was ripe for wider development. The row of semi-detached villas on the west side of Edderston Road were built in the late 1890s.

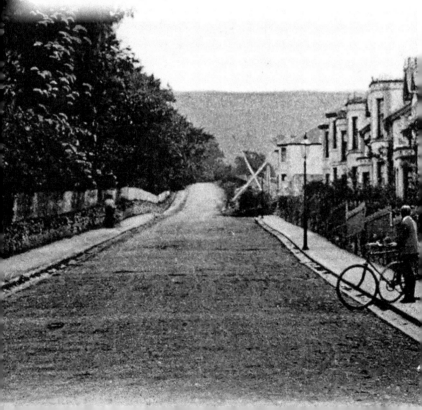

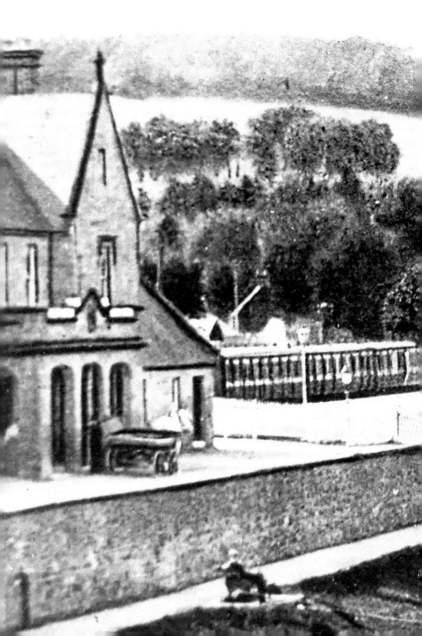

31. CALEDONIAN STATION

The extension of the Symington, Biggar & Broughton Railway to Peebles opened in 1864. It terminated at Caledonian Railway's station (known as Peebles West to differentiate it from the NBR station across the river) just below the south-west corner of Tweed Bridge. A rail track and bridge were built to link the stations of these rival railway companies, but only for goods trains. Passengers could stroll over the river bridge to book into the Caledonian Railway Hotel (now Coltman's Bistro) at the foot of the High Street.

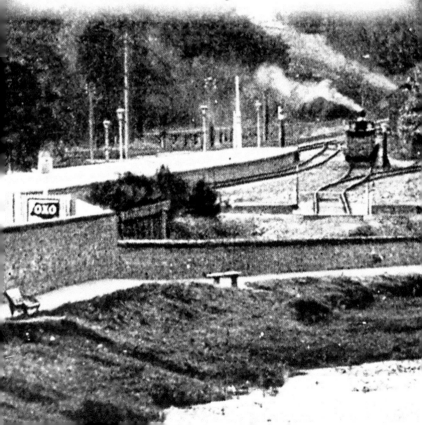

32. TWEEDSIDE WALK

This riverside path is as popular today as it was in the early twentieth century, but the buildings at either side of the bridge have gone. Thorburn's Mill – whose site was previously occupied by a corn mill – was burnt down in 1965 and a modern swimming pool was built there in 1984. The station was demolished after the Caledonian line closed to goods in 1954 (passenger trains ceased in 1950) and Tweedside Court, a complex for the physically disabled, was completed in the 1970s on the land.

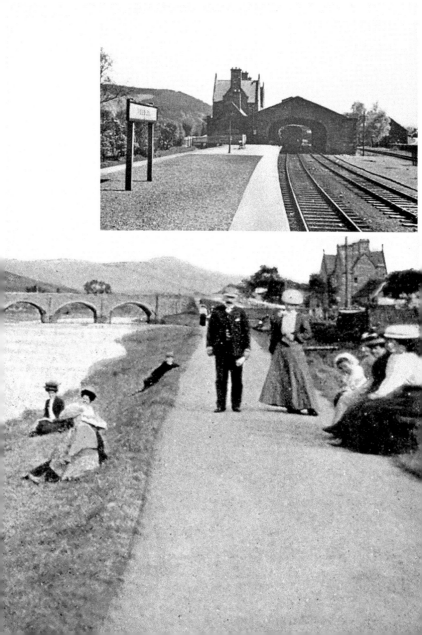

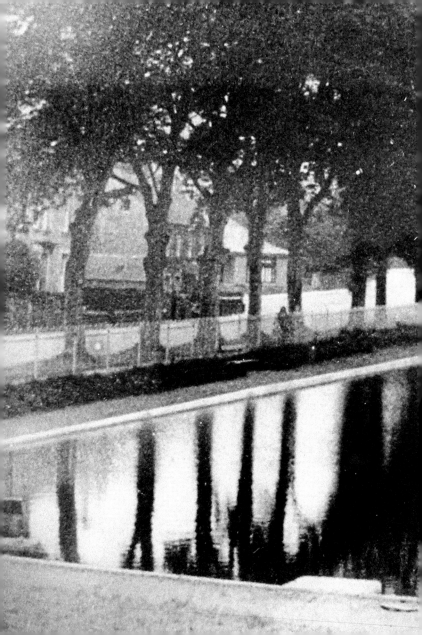

33. CURLING POND

Most visitors who drive into Kingsmeadows car park will be unaware that this was once a curling pond. The riverside location used to be known as Ninian's Haugh, and prior to the railway embankment being built, the area flooded and froze in the winter, creating a natural curling pond. Once it became unusable the curlers moved to a pool in the grounds of Kingsmeadows House until the land was purchased for housing in the 1950s, at which time the artificial one in the photograph was provided.

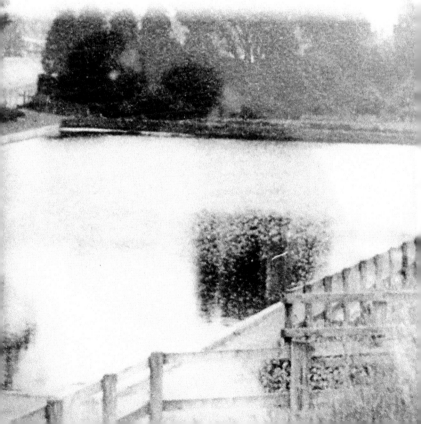

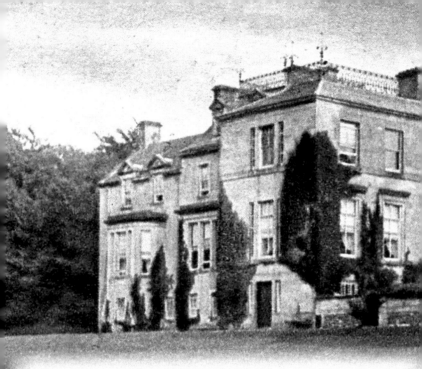

34. KINGSMEADOWS HOUSE

Land known as the Kings Meadows on the south side of the river was purchased by the Hay family in 1570, when they resided in Haystoun tower house (later extended) until Sir John Hay built Kingsmeadows House in 1795. The latter became the family seat for himself, his wife Elizabeth Forbes and their fifteen children, while his two spinster sisters remained at Haystoun. In 1920 it was sold to the Mitchell family (benefactor to the Mitchell Library in Glasgow) and was used in the Second World War as a maternity hospital for both local and Glasgow mothers. After a period in the ownership of Standard Life, it has recently been converted into luxury apartments.

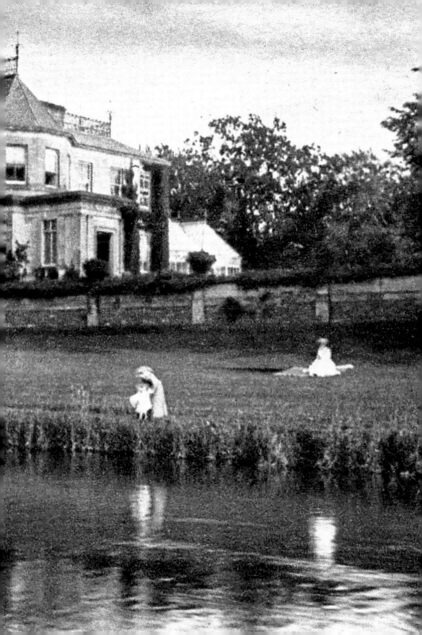

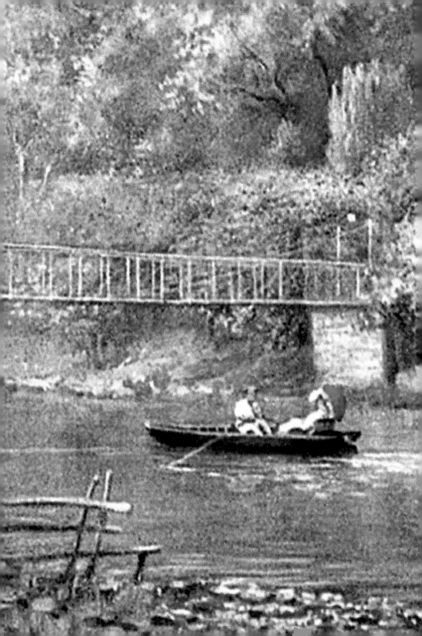

35. WIRE BRIDGE

It is said that Sir John Hay, having moved into Kingsmeadows House, was irritated by the continued use of his grounds as a shortcut by locals walking to church or the town. As the family also owned most of the land on the north side – Venlaw, Soonhope and Eshiels – he decided to have a bridge put across the River Tweed a mile downstream, thereby protecting his privacy and giving him access to his other property. It gradually decayed and the end gates were locked after the Second World War. It was demolished in the 1950s after extensive flood damage.

36. PRIORSFORD BRIDGE

To celebrate the Diamond Jubilee of Queen Victoria, Sir John Hay donated parts of Kingsmeadows to the citizens of Peebles to use as parkland (named Victoria Park). The idea of a bridge linking it to the town was suggested in 1902 and local engineer Robert Inglis of Tantah House offered to submit a design for a suspension bridge. Funds were raised by public subscription and the crossing was completed in 1905.

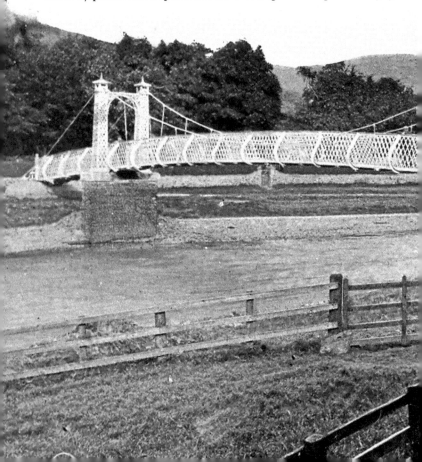

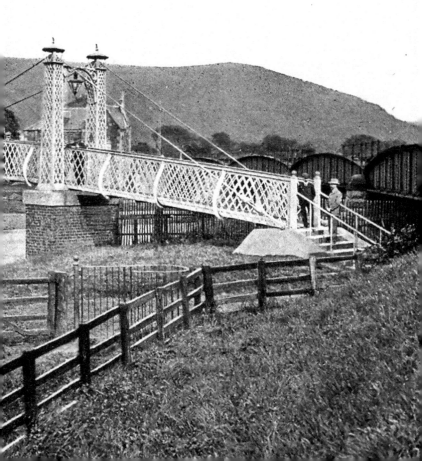

Priorsford Bridge, Peeble.

36. PRIORSFORD RAILWAY CROSSING

In order to connect the two stations in Peebles, another bridge had to be constructed across the river to carry the loop between them. Firstly, the south side of Tweed Bridge at the Caledonian station was altered to create a single arch under the road. The line was then laid on an embankment to Priorsford where the river crossing swept round in an arc, before going under the Innerleithen Road Bridge into the goods yard at Peebles East station. This link was not used for passenger traffic.

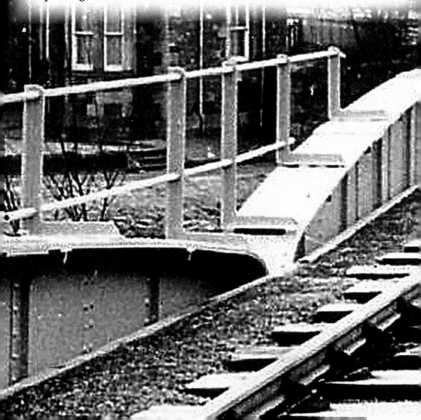

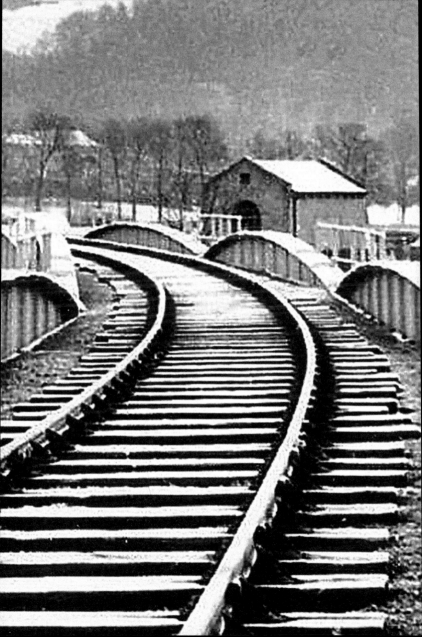

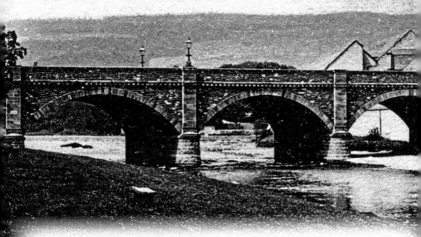

37. TWEED BRIDGE

It is easy to see the history of the river crossing underneath the arches of Tweed Bridge, from the original 8 feet of the fifteenth century, through the widening in 1834 to the present-day 40-foot-wide bridge. It is generally agreed that a wooden bridge was in place here by 1465, one of only three bridges across the 97-mile River Tweed, the other places being Kelso and Berwick. Burgh records during the centuries frequently refer to the cost of repairing and maintaining the essential structure.

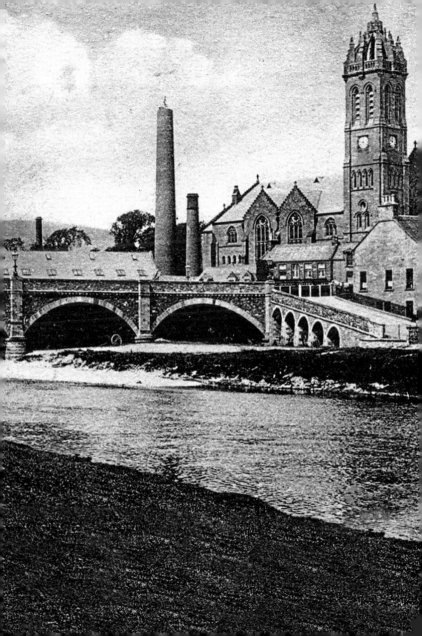

37. PISSOIR ON TWEED BRIDGE

Prior to the bridge alterations in late 1890s, a curious structure was precariously attached to the north-west corner, namely a Victorian pissoir, which can be seen in the curvature of the stone wall. The image illustrates the changes that have occurred at the foot of the High Street over the twentieth century: the large house on the right at the top of Portbrae was used as the offices for the constabulary, newly established in 1840 before the next-door cottage was demolished and a police station built there in 1887.

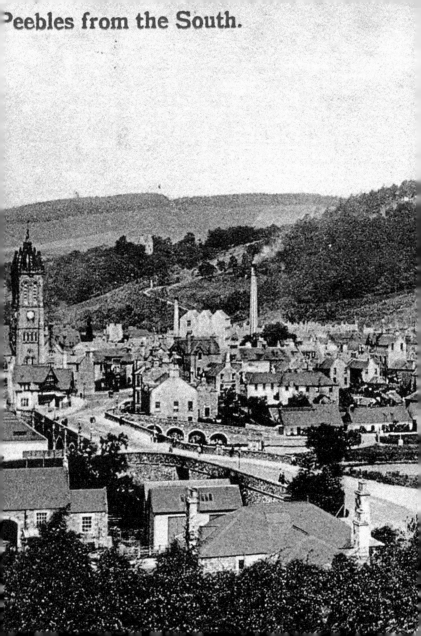

Peebles from the South.

38. PEEBLES FROM THE SOUTH

This photograph was taken from the elevated ground called Frankscroft, which was a popular location for building Victorian villas due to the commanding panoramas of the burgh. The Caledonian station is visible in the bottom left, and in the centre the curved wall of the Tontine Hotel's ballroom can be seen – now obscured by a modern extension. In front, along the edge of Tweed Green, is the stable block for the establishment.

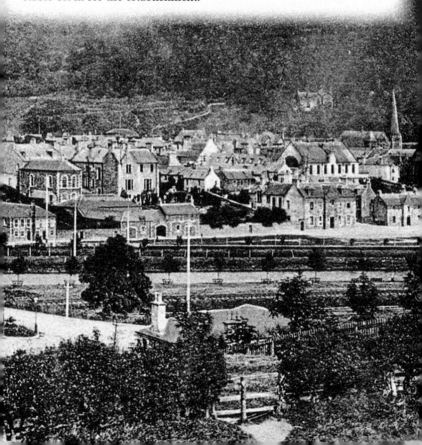

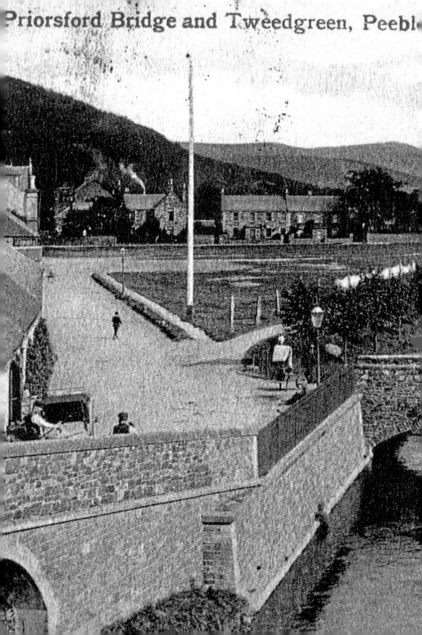

Priorsford Bridge and Tweedgreen, Peebl

39. MILL LADE

There was a mill lade from Tweedside Mills, which ran under Tweed Bridge and flowed into the river halfway along Tweed Green, which was crossed by this small footbridge at the foot of Portbrae. The spot is now marked by a wishing well, covered by a metal grid and embellished with the three fish of the Peebles coat of arms. The metal poles of the communal drying green are still standing.

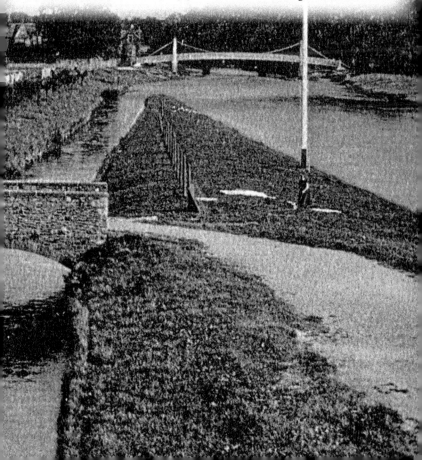

40. TWEEDSIDE MILL

The corn mill below Castlehill (beside the river) was taken over by Thomas Dickson in 1856 and rebuilt as a manufacturing house, producing garments from local cloth using water-driven machines. It was the first sign of the positive impact that the railway had on Peebles' economy. The mill was then taken over by Hawick company Laing & Irvine, who introduced power looms to produce tweed. In due course Walter Thorburn & Bros, who built Damdale Mill in 1869, took over this one too. It was burnt down in 1965.

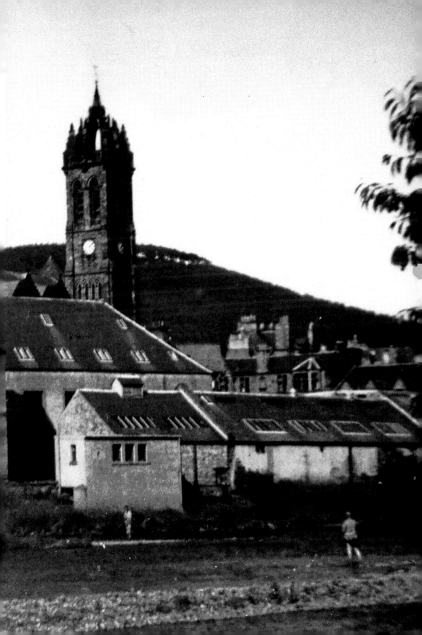

41. PEEBLES PARISH CHURCH

The knoll on which the present church sits was the site of twelfth-century Peebles Castle, which was used by royalty, who favoured the area for its good hunting. The tower-house fell into disrepair after the mid-1300s and a bowling green was created on the mound in 1720, which was used for 150 years. By 1784 the fabric of the Cross Kirk was crumbling so the town council agreed to a new parish church on Castlehill. Unfortunately, the design (and draughts) proved very unpopular with Peebleans and it was replaced in 1887 with the one seen today.

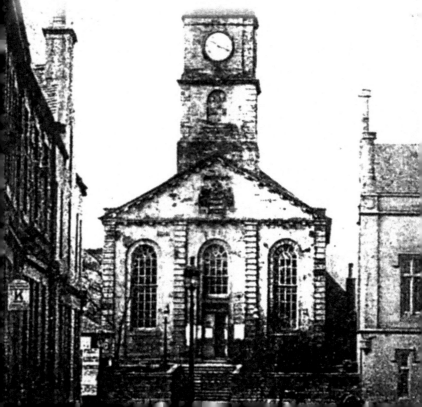

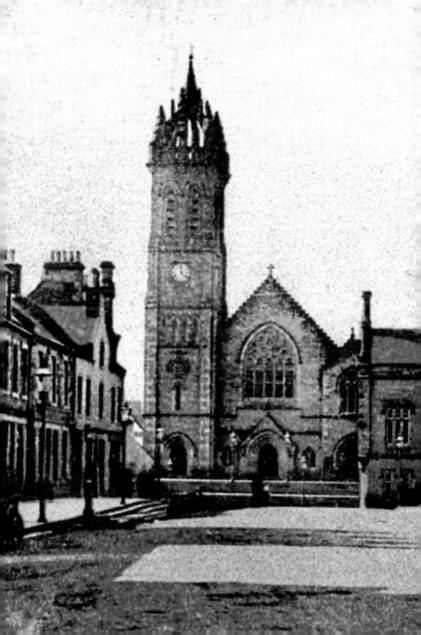

42. BANK HOUSE

This was built on the site of the medieval Chapel of the Virgin when it was cleared in the late eighteenth century. It is so named because the building was occupied first by the Union Bank in 1860, then the Commercial Bank in 1871. The elegant Italianate house then became home to the Buchan family: the mother, Helen; daughter, Anna, whose nom de plume was 'O. Douglas'; and brother, Walter, who served Peebles well as solicitor, town clerk and procurator fiscal between 1906 and 1954. John Buchan, 1st Baron Tweedsmuir, his older brother, was a prolific writer, a Unionist politician and ultimately governor general of Canada.

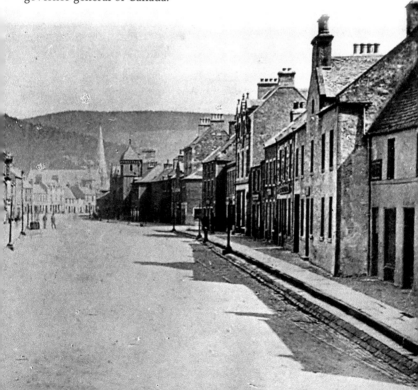

43. CUDDY BRIDGE

The history of a crossing over Peebles Water, the early name for Edderston Water, is sketchy and the medieval layout of the burgh was such that the west end of the High Street was 'blind', being occupied by the complex of Peebles Castle, the almshouse and the Chapel of the Virgin. A steep-angled arch is thought to have been used until a level stone one was built in 1857. This required widening by 1950, but the controversial plans included the demolition of Bank House, which angered locals. A compromise was reached resulting in the present building, complete with the red side door.

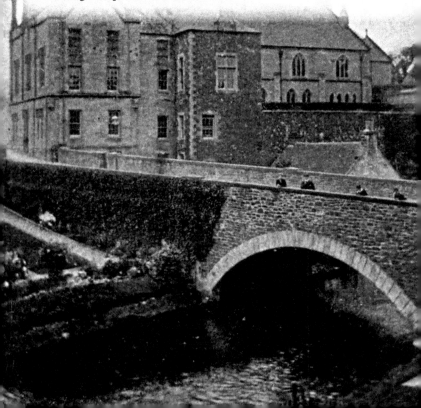

44. TONTINE HOTEL

Prior to this hotel being built in 1808, there had been no competition for the Cross Keys in Northgate, so the Tontine, with its palatial ballroom, was a welcome addition to the town. It was named after the method of raising capital by subscription, invented by Italian banker Lorenzo de Tonti, whereby annual shares were paid out to contributors. French parole prisoners from the Napoleonic Wars were used as labourers for the construction.

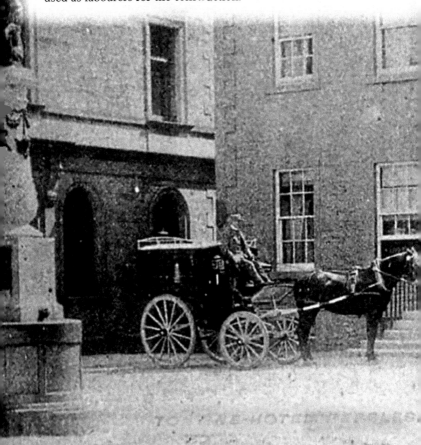

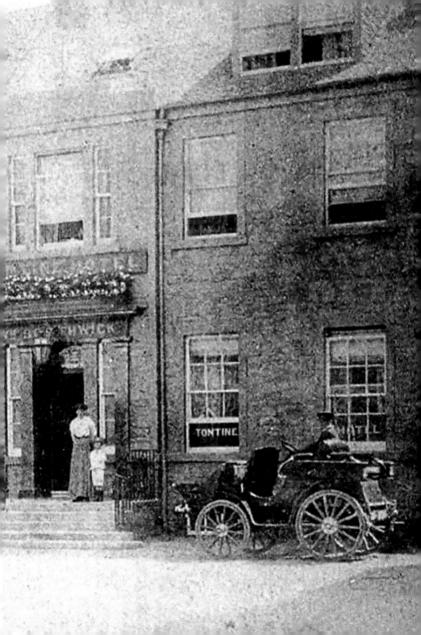

45. VEITCH MEMORIAL

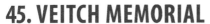

The granite drinking fountain in front of the Tontine Hotel commemorates Professor Veitch, who was born in 1829 and raised in Biggiesknowe. He taught logic, rhetoric and metaphysics at Glasgow University. His passion for the surrounding countryside, its wildlife and history inspired him to compose a large volume of poetry.

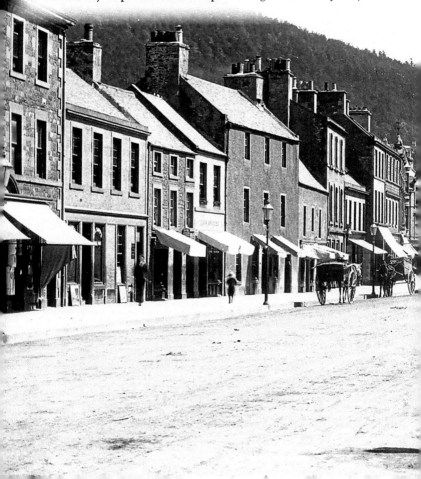

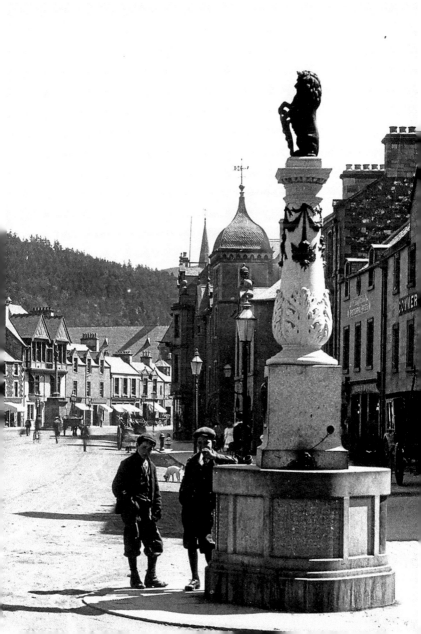

46. HIGH STREET

The symmetrical lines of shop frontages in twenty-first-century Peebles hide a wealth of earlier history that can be seen by those with an enquiring mind and observant eyes. A pend at No. 63 leads to a cobbled area, Parliament Square, where an urgent meeting was held after the capture of David II in 1346. A marriage lintel is on the west side 'RS HM 1743', and across the street, down a close, at No. 82 there is an even older one 'IF MR 1648'. A high-walled enclosure off Dean's Wynd is the seventeenth-century slaughterhouse, which was used until 1895. The diversity of architecture spans the eras from the sixteenth century, when it was laid out, to the present day.

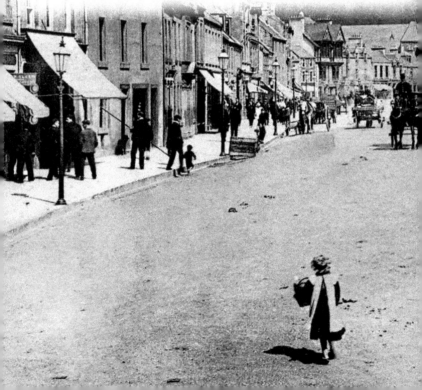

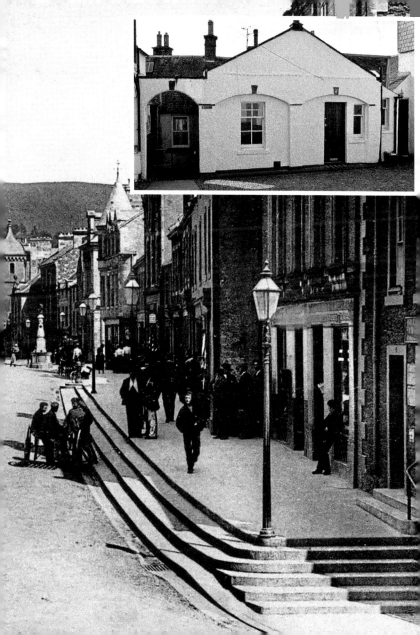

Also available from Amberley Publishing

A fascinating look at the lesser-known history of Peebles.
978 1 4456 5924 4
Available to order direct 01453 847 800
www.amberley-books.com